Resting Bitch Face Coloring Book

For nice women with unintentionally judgy faces

Cora Delmonico

Tip: Colored pencils, gel pens, and crayons are the best for this paper. But if you're a marker girl, put a sheet of paper in between pages to prevent bleed through.

I use sarcasm in social situations because apparently telling people to fuck off is frowned upon.

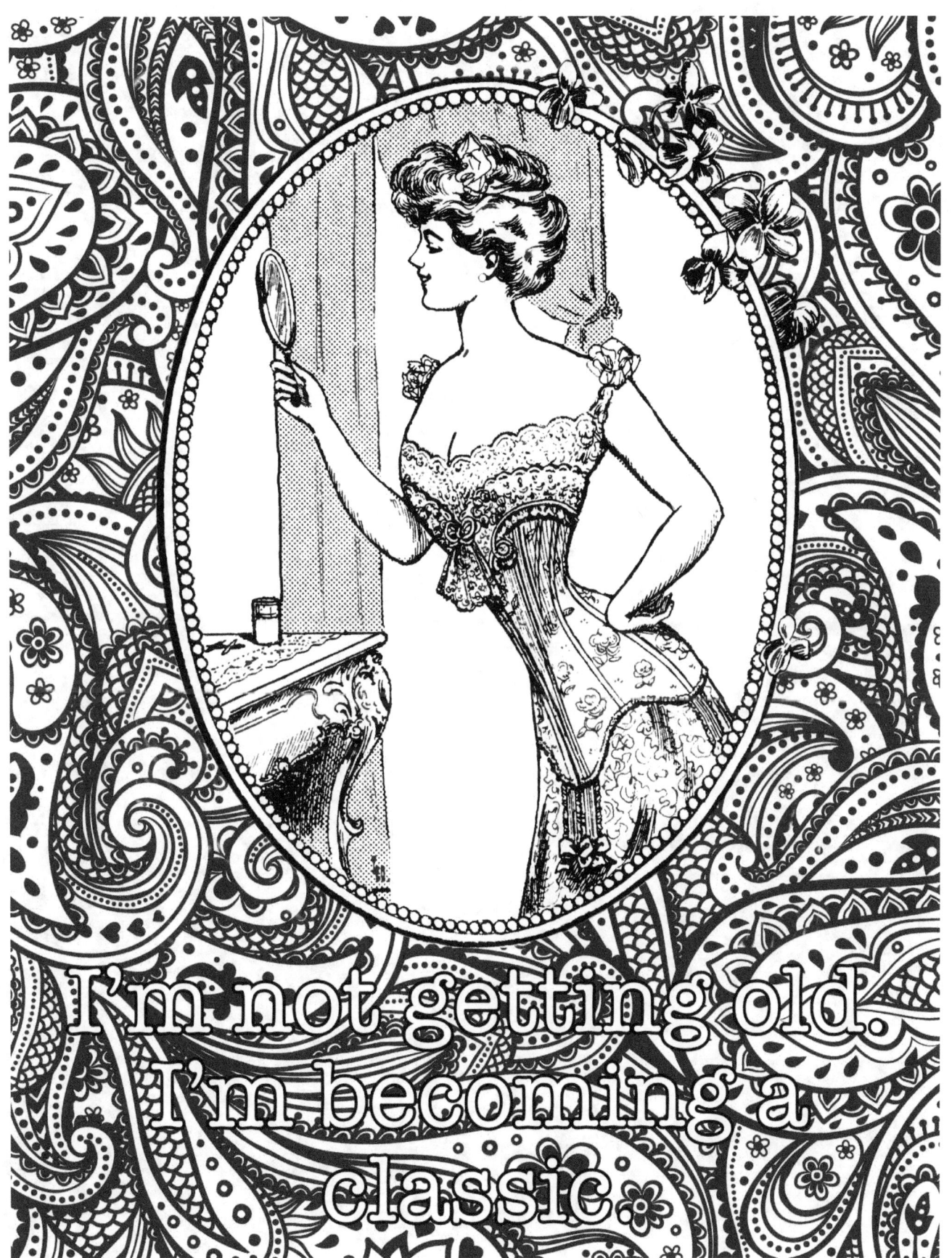

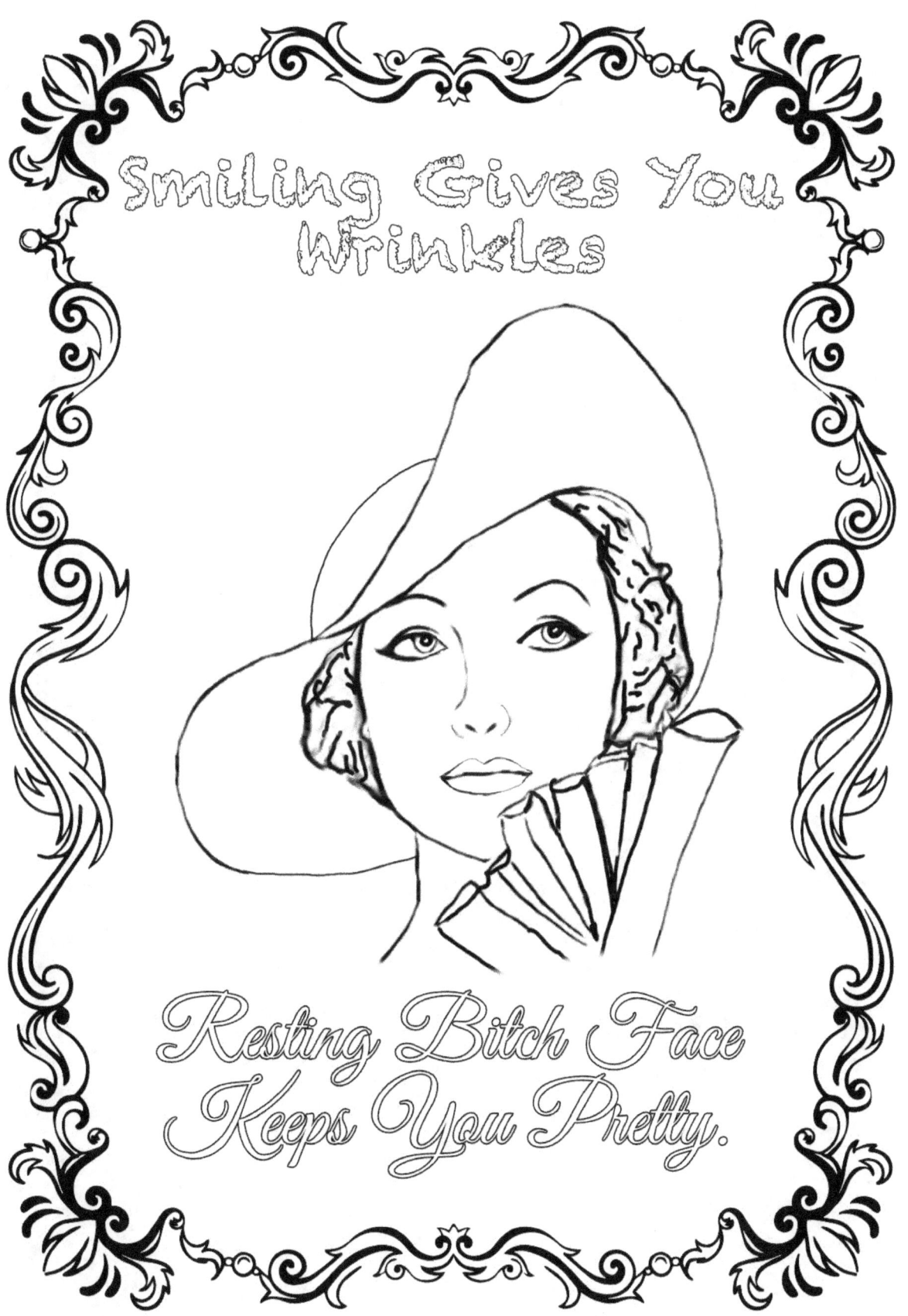

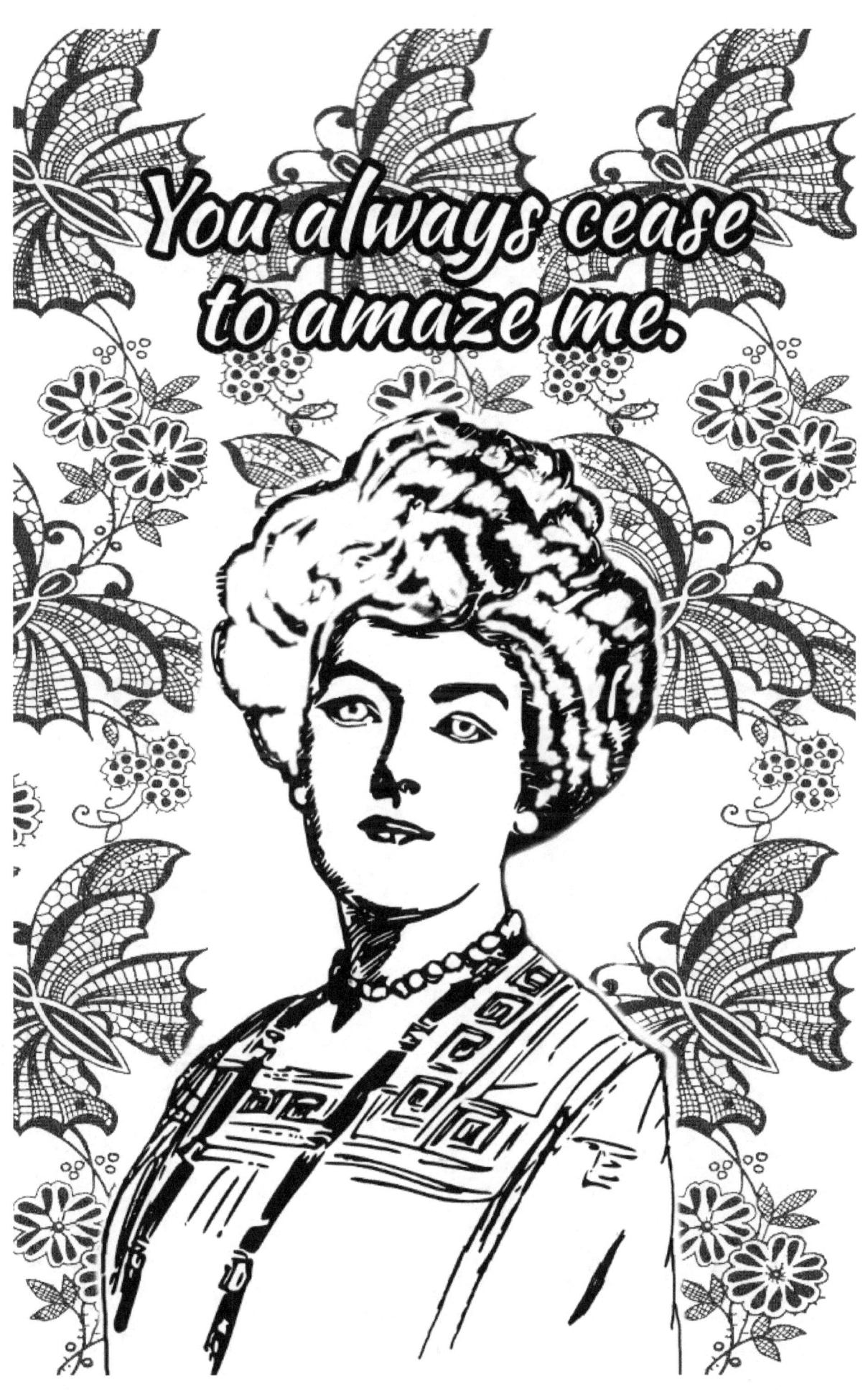

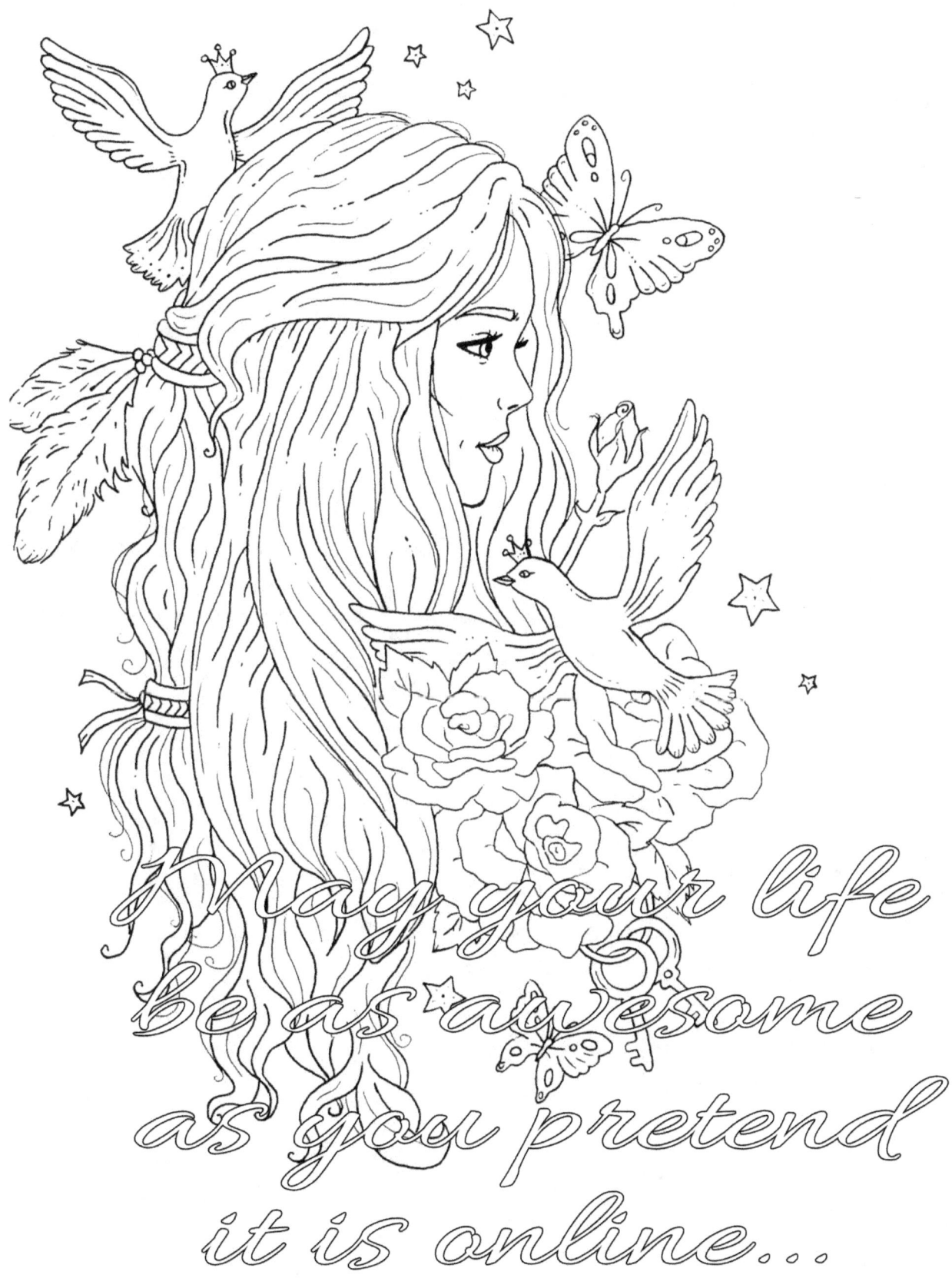

The problem with some people is that they're breathing.

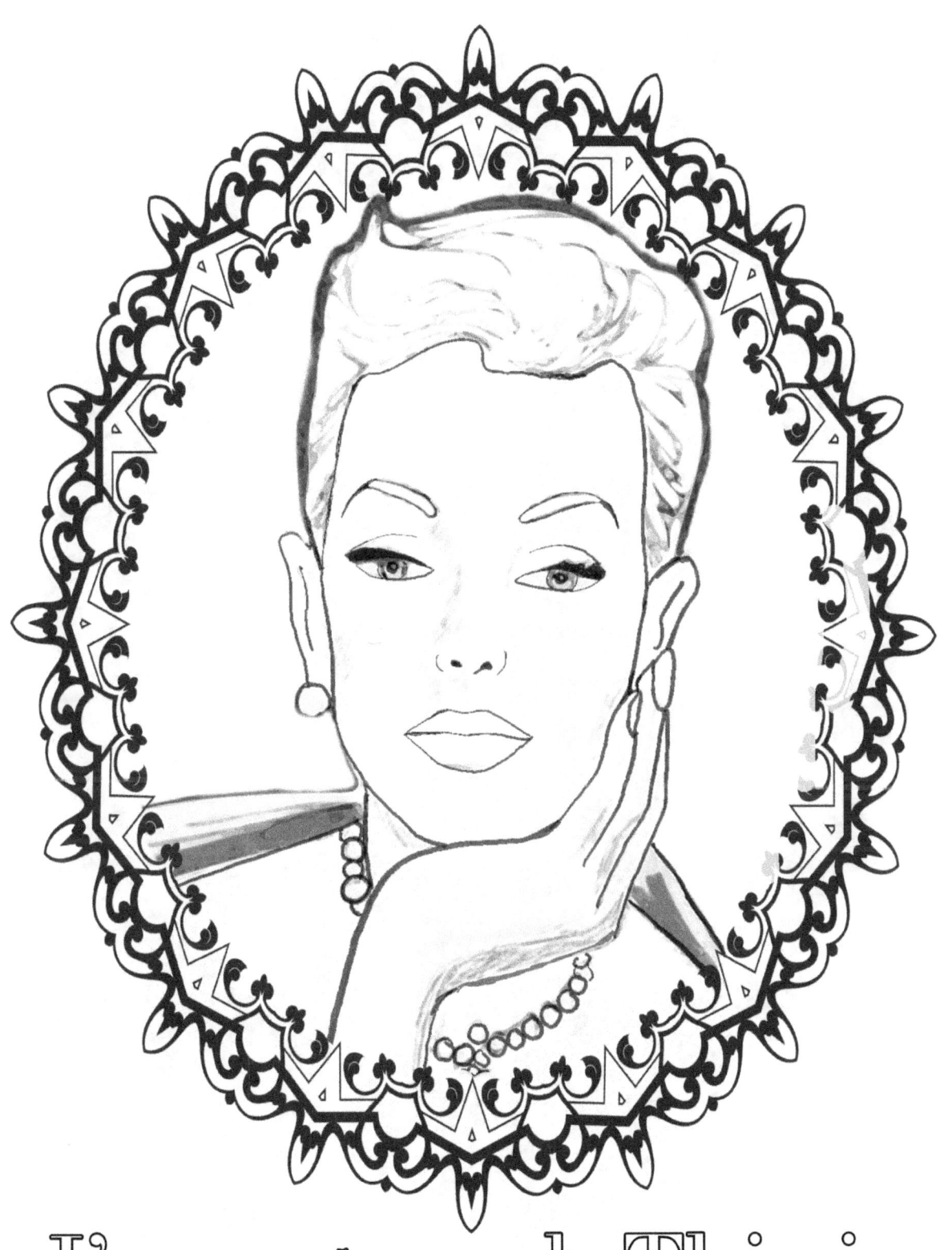

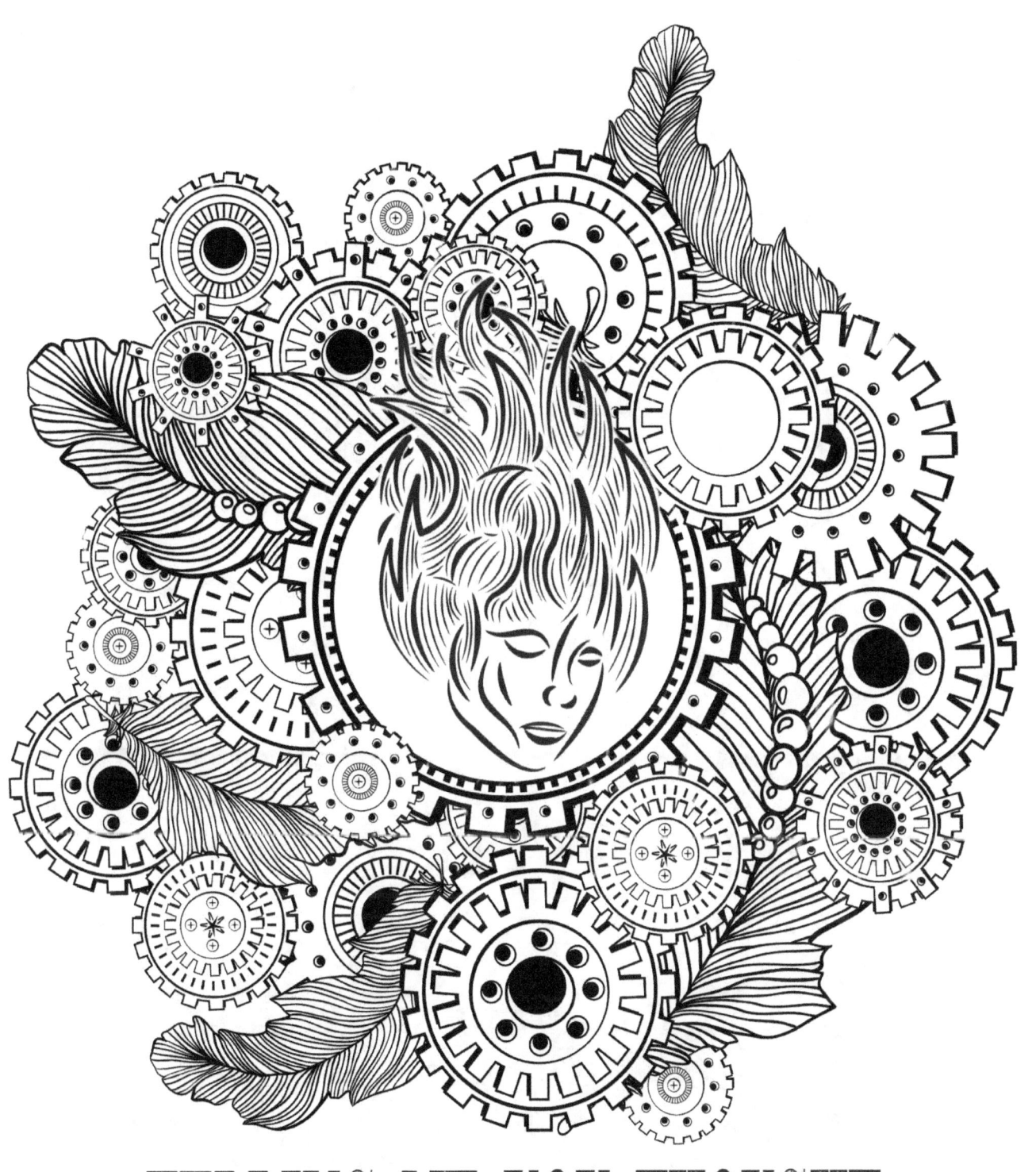

TELLING ME YOU THOUGHT I WAS A BITCH WHEN WE FIRST MET = AWKWARD!

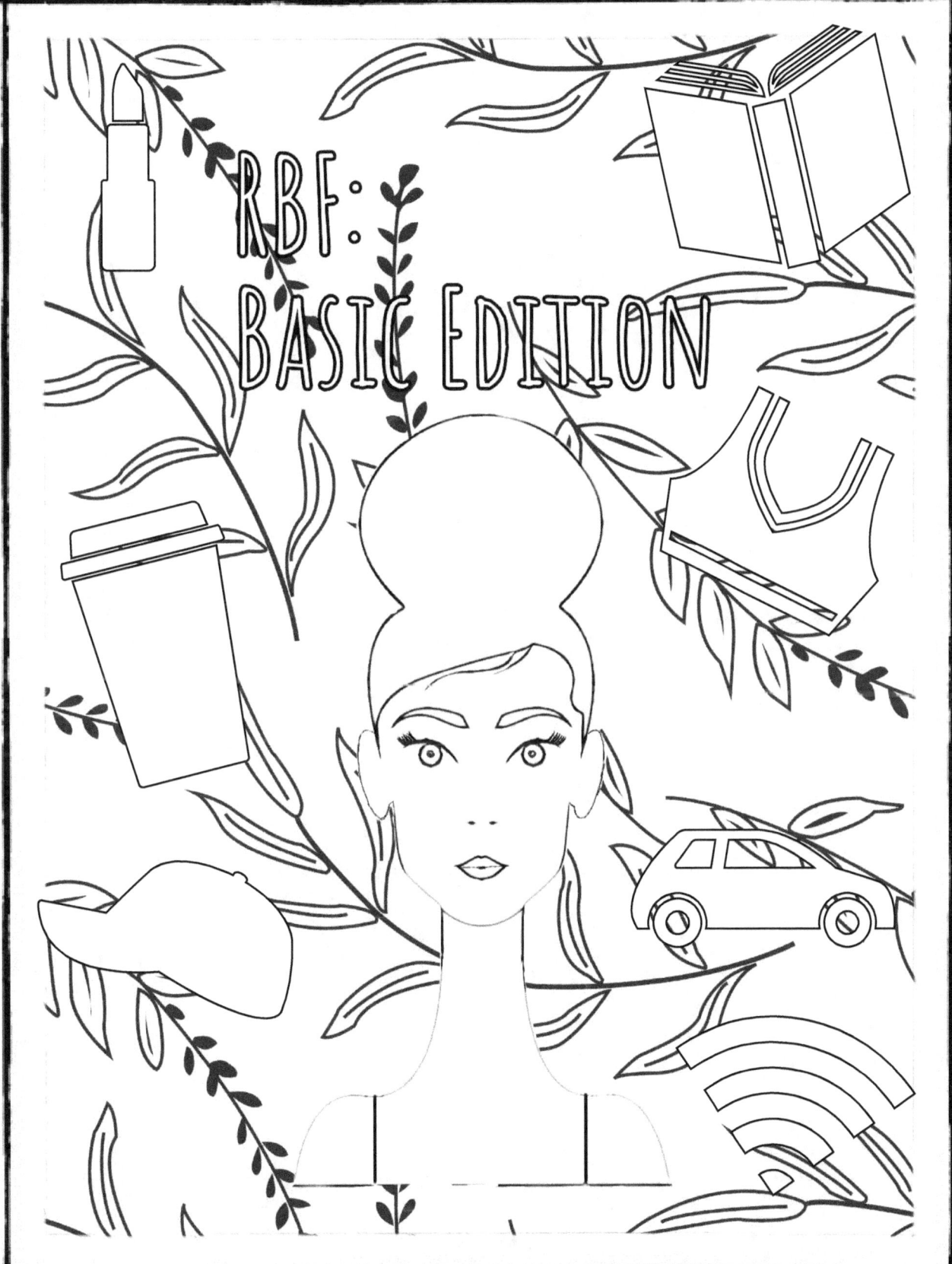

I'M NOT REALLY A BITCH...

Just Kidding.

Go fuck yourself.

RESTING BITCH FACE BENEFIT:

It saves me from conversations I don't want to be a part of

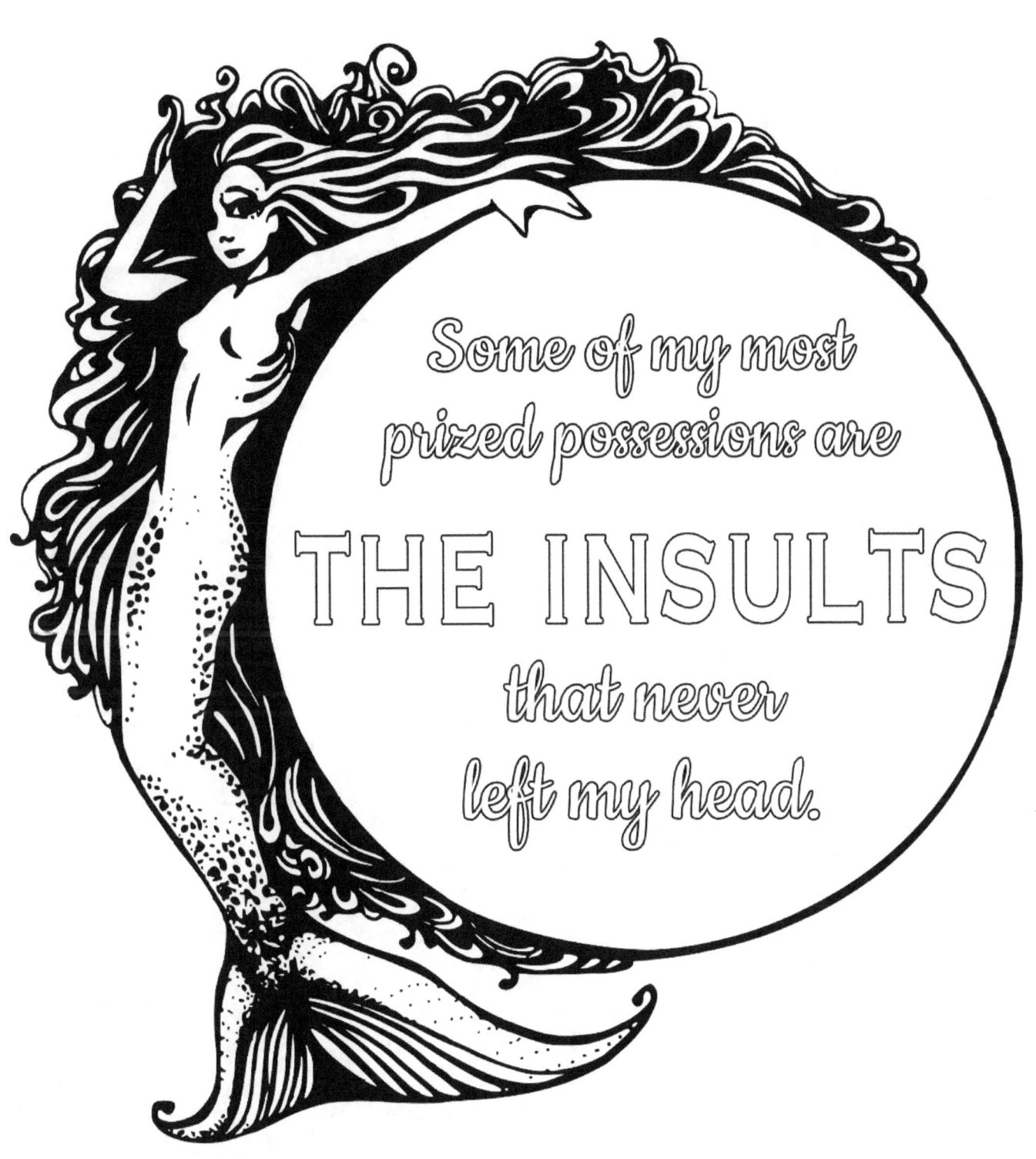

It's not my job

to blow sunshine up your ass.

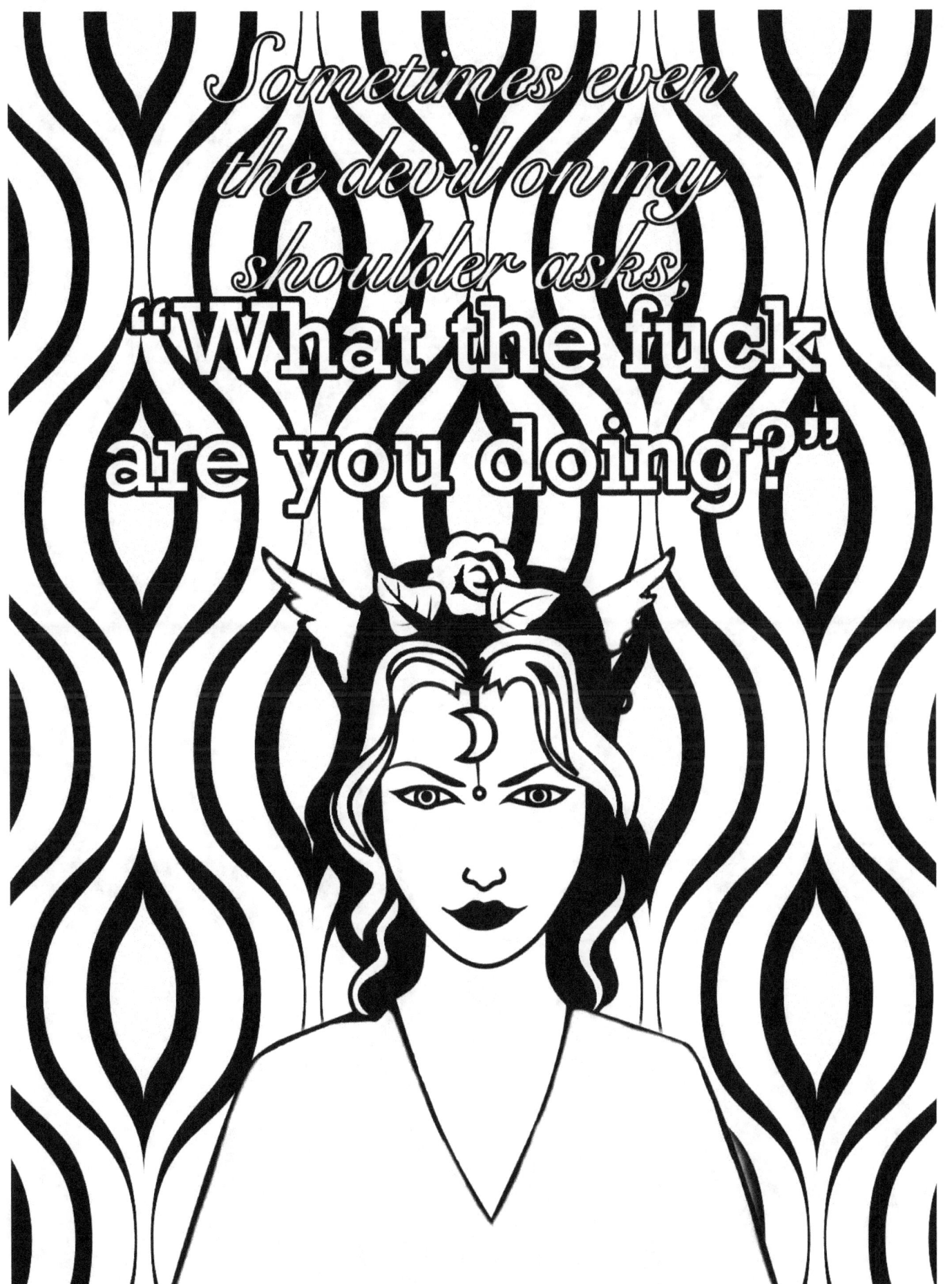

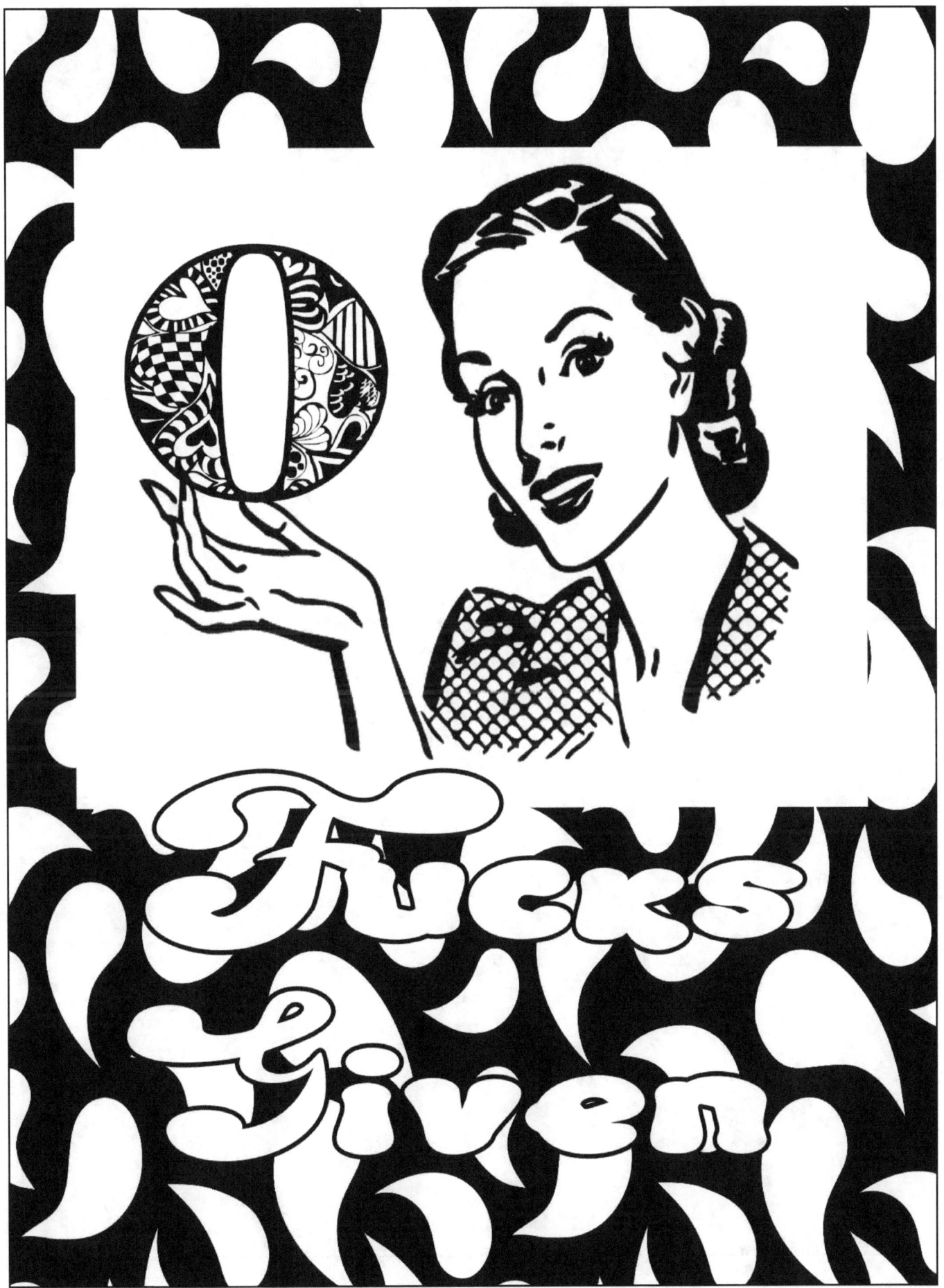

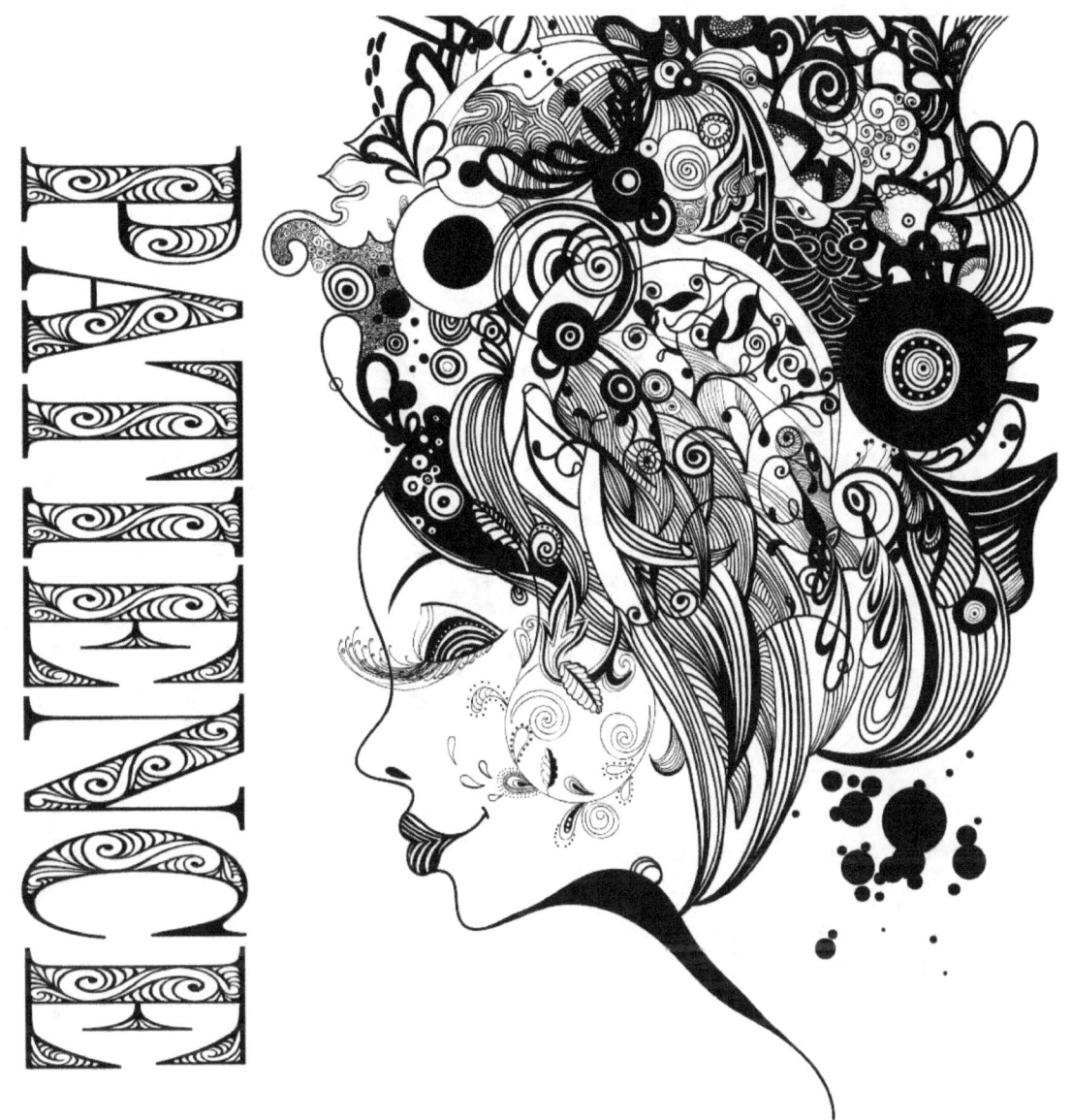

PATIENCE

What you have when there are too many witnesses.

A wise woman once said,
"Fuck this shit!"
And lived happily ever after.

I rolled my eyes so hard,

I got a good look at my ass.

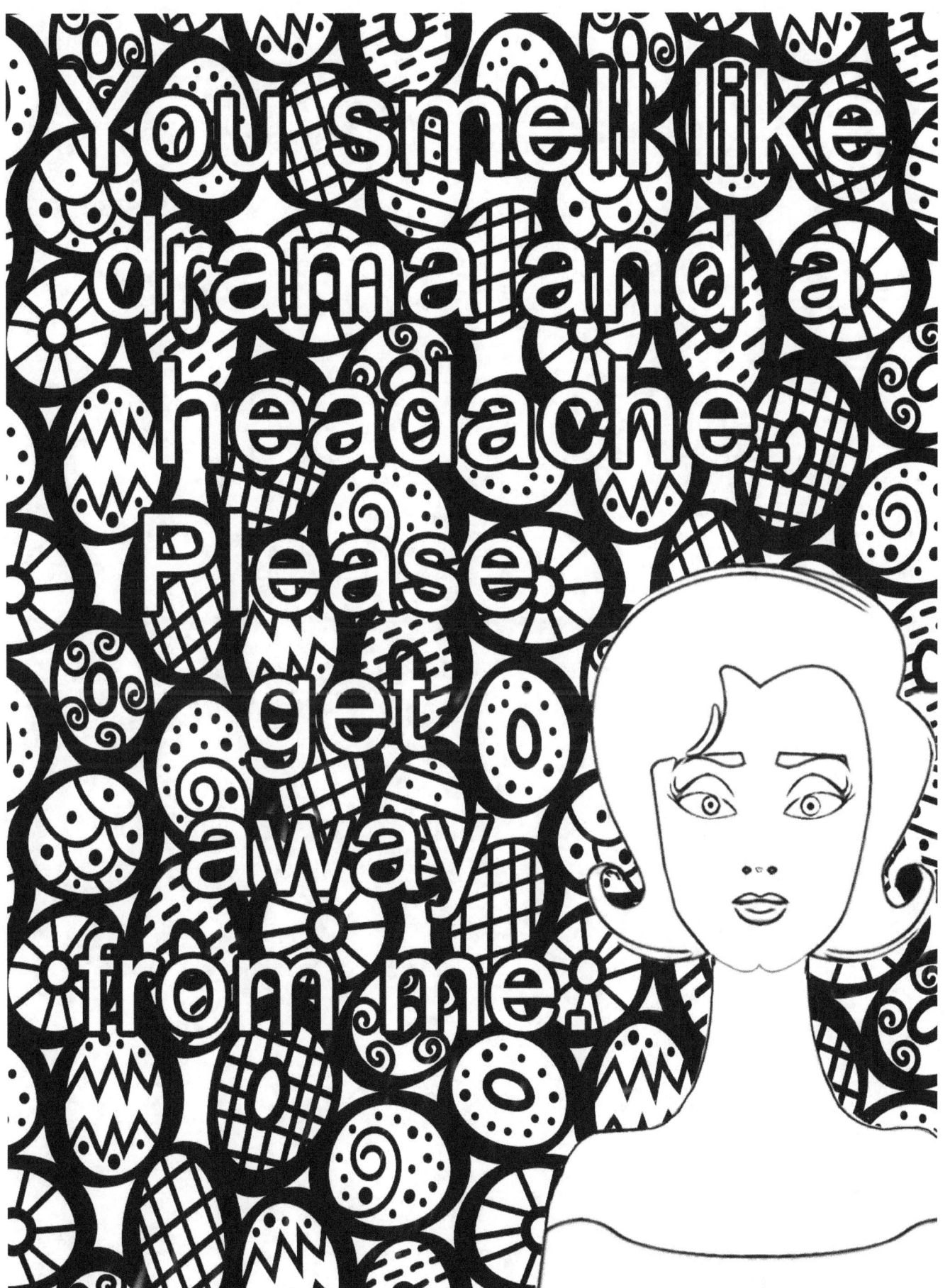